INSTANT WALL ART:
ASTROLOGICAL DESIGNS

INSTANT WALL ART:
ASTROLOGICAL DESIGNS

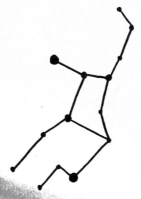

Ready-to-Frame Wall Art Customized
for Every Zodiac Sign

Features
Three Tear-Out
Prints
Per Sign!

Introduction by Constance Stellas

Adams Media

New York London Toronto Sydney New Delhi

Adams Media
An Imprint of Simon & Schuster, Inc.
57 Littlefield Street
Avon, Massachusetts 02322

First Adams Media trade paperback edition October 2019

ADAMS MEDIA and colophon are trademarks of Simon & Schuster.

For information about special discounts for bulk purchases, please contact Simon & Schuster Special Sales at 1-866-506-1949 or business@simonandschuster.com.

The Simon & Schuster Speakers Bureau can bring authors to your live event. For more information or to book an event contact the Simon & Schuster Speakers Bureau at 1-866-248-3049 or visit our website at www.simonspeakers.com.

Interior design by Priscilla Yuen

Manufactured in the United States of America

10 9 8 7 6 5 4 3 2 1

ISBN 978-1-5072-1146-5
ISBN 978-1-5072-1147-2 (ebook)

INTRODUCTION

Your Sun sign: You already know that it can provide you with insight into your relationships, help you choose a career path, and even give you a better understanding of your personality. Now, with *Instant Wall Art: Astrological Designs*, you can bring the power of the zodiac into your home too. Throughout this book, you'll find more than thirty-six gorgeous illustrations of the zodiac signs and symbols that can make your home feel like a true reflection of you.

Each astrological sign is represented in three distinct and beautiful ways, including:

◇ An image that showcases the sign's star constellation.
◇ An artistic woodcut that features each sign's symbol.
◇ A simple yet elegant brushstroke image that portrays the sign's glyph with understated grace.

BRING THE POWER OF YOUR SIGN HOME

Your astrological Sun sign connects you with your essential energy, and having a special object that relates to this personal energy signature can bring focus to your life. Exhibiting wall art with your astrological symbol is like having your own cosmic coat of arms. Your Sun sign shows what makes your personality shine, and symbols connected with your sign can produce vibrations that will enliven and enhance your living space. Why not use these beautiful Sun sign images as art in your home, gifts for others, or an evolving home art show to suit the various aspects of your personality?

Your Sun sign reflects the energy that resides within you—who you are in the depths of your being—so use these unique pieces to personalize your décor and make your space truly a reflection of you. Simply choose the prints you love, hang them on your walls, and let them empower you and your home all year round!

Your Sun sign is determined by the date you were born. It represents your personality, preferences, strengths, and weaknesses. Each of the twelve signs is unique with distinctive characteristics and intrinsic gifts.

Your Sun sign is also influenced by your essential element. The essential elements are fire, earth, air, and water, and they speak to certain tendencies in each zodiac sign. For example:

◊ Fire signs tend to be passionate and temperamental.
◊ Earth signs are grounded and practical.
◊ Air signs are all about ideas, relationships, and communication.
◊ Water signs are intuitive and emotional.

Following is a brief description of each Sun sign, its element, its glyph, and where in your home you could place the sign's astrological wall art. We'll start at the beginning of the zodiacal year with Aries.

NOTE: A word about masculine and feminine signs. In astrology, all fire and air signs are considered masculine; water and earth signs are considered feminine. Therefore, we will use the pronouns *he/his* for masculine signs, and the pronouns *she/hers* for feminine signs.

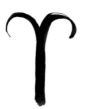

ARIES March 21–April 19
ELEMENT **Fire**
MOTTO **I AM.**

Aries marks the beginning of spring. His symbol is the Ram. The glyph for Aries—who likes to butt heads with the world—is the Ram's brow and curled horns. Aries is always in a hurry, so a good placement for any of his wall art would be in the hallway on the way out the door. Placing Aries art in the bedroom might be too energetic to get a good night's sleep.

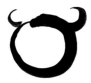

TAURUS April 20–May 20

ELEMENT **Earth**
MOTTO **I HAVE.**

The symbol of Taurus is the Bull. The Bull is planted solidly on the earth and is comfortable with the practical realities of life. She is usually placid and even-tempered, but when angered, watch out! The glyph for Taurus is the horns of the Bull atop a circle. Taurus loves comfort, so a good placement for any of her wall art would be in the bedroom or a relaxing living room.

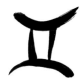

GEMINI May 21–June 20

ELEMENT **Air**
MOTTO **I THINK.**

Gemini's symbol is the Twins, and his glyph is usually depicted by a graphic meant to resemble the Roman numeral II, which symbolizes duality and the conflict of contradictory mental processes. Gemini is the messenger and communicator of the zodiac. The best placement for Gemini art would be in a study, near a reading chair, or close to a favorite place to speak on the phone. This can connect him to the importance of ideas and communication.

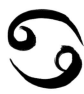

CANCER June 21–July 22

ELEMENT **Water**
MOTTO **I FEEL.**

Her season begins with the summer solstice. Cancer is the Crab who carries her protective shell with her. The glyph represents two breasts, symbolizing the nurturing mother who gives life and nourishment. Watery Cancer's feelings can change by the hour and are heavily influenced by the Moon. The ideal placement for Cancerian wall art would be in the bathroom, kitchen, or near a hot tub. A comfortable nook in the living room is also cozy.

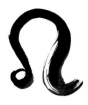

LEO July 23–August 22

ELEMENT **Fire**
MOTTO **I WILL.**

Leo is ruled by the Sun. His symbol is the Lion, king of the jungle, and the glyph for Leo is the curved Lion's tail and the full mane—which is his pride. Leo effortlessly and generously leads people. The best placement for Leo art would be in a sunroom, near the door to a patio or deck, or on the back of the front door. When you leave, it will remind you that you are going to your people.

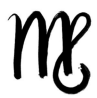

VIRGO August 23–September 22

ELEMENT **Earth**
MOTTO **I ANALYZE.**

Her symbol is the Maiden who gathers the harvest and seeks perfection in all she does. The glyph for Virgo is ancient and connected to the girdle of hymen, which was part of fertility rituals. The best placement for your Virgo wall art would be wherever you concentrate. It could be a study, library, kitchen, or garden. Placing the wall art here reminds you to seek perfection but not get too fussy about details.

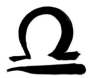

LIBRA September 23–October 22

ELEMENT **Air**
MOTTO **I BALANCE.**

Libra begins with the fall equinox. He is the sign of the self in relationship to others. The glyph for Libra is the scales of justice, and Libra must balance all sides of a relationship, question, or theory before making a decision. The scales also symbolize his unwavering belief in fairness to others. The perfect place for your Libra wall art would be in the rooms where you socialize and in the bedroom; balancing your day and thoughts before bed is a very good way to encourage deep sleep.

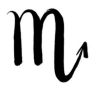

SCORPIO October 23–November 21

ELEMENT **Water**
MOTTO **I TRANSFORM.**

Scorpio is perhaps the strongest sign of the zodiac. The glyph for Scorpio shows the stinger of the unevolved Scorpion who would rather sting herself to death than forgo the pleasure of the sting. The other two symbols for this powerful sign are the Eagle and the mythical Phoenix, which helps Scorpio move her energy from the dark into the light. The best place for putting Scorpio wall art is in a corner of the most special, secret place in your home. This could be the bedroom, a basement hideout, or the bathroom. If you are the only person who sees this wall art, the mystery of Scorpio will be preserved.

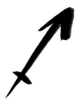

SAGITTARIUS November 22–December 21

ELEMENT **Fire**
MOTTO **I PERCEIVE.**

Sagittarius is a seeker of wisdom and a great traveler. His symbol is the Centaur—half man, half horse. The glyph is the arrow of truth that Sagittarius shoots into the air. He always speaks the truth even when it may be uncomfortable. Your wall art should hold a prominent place in your home. A living room, an open great room, an altar just for you—all would be perfect places to celebrate the bounty of Sagittarius.

CAPRICORN December 22–January 19

ELEMENT **Earth**
MOTTO **I USE.**

Capricorn begins at the winter solstice. Her glyph and the sign itself are enigmatic. She is both the mythical Sea Goat and the Land Goat who climbs the craggy mountains. The glyph contains the forepart of a Goat with the tail of a Fish. The earthy Goat never stops climbing higher and higher, and the Fish's tail signifies the depths of the ocean.

This sign is powerful and determined to make her mark. Capricorn wall art would feel comfortable in front of or behind a large desk where you work, near an antique cabinet, or perhaps on a wall with pictures of ancestors and family members, since continuity and family are important to Capricorn.

AQUARIUS January 20–February 18

ELEMENT **Air**

MOTTO **I KNOW.**

Known as the Water Bearer, Aquarius symbolizes the servant of humanity who pours out the water of knowledge to quench the thirst of the world. He is inventive and unique. Aquarius's glyph is two waves on top of each other. The sudden lightning bolt of insight and the electrical energy of the sign together yield unique wisdom. Place your wall art where you feel most unique and individual. The best idea would be to make the picture movable so you can place it at your whim.

PISCES February 19–March 20

ELEMENT **Water**

MOTTO **I BELIEVE.**

Pisces's glyph is two Fish tied together; some sources say they are two Seahorses. One Fish lives under the sea and swims in the depths of imagination and dreams; the other Fish is above the sea and participates in the world as it is. Pisces must go into the sea depths to renew and protect her sensitive nature. Pisces wall art should be in a place of retreat where she can connect with her depths and feel safe. A bathroom, sunroom with a fountain, or in the bedroom would all be perfect places for Pisces to remember herself.

HOW TO FRAME
YOUR PRINTS

Now that you know a bit more about your Sun sign, it's time to enlighten your living spaces with the intrinsic energy they hold. Using the prints in this book you can create a unique display to showcase all the different aspects of your sign and make your home truly reflect who you are.

There are countless ways to use and enjoy these wall art pictures. You could:

◇ Try framing your friends' signs as unique housewarming gifts.
◇ Create a beautiful and eclectic mix-and-match display combining you and your partner's signs to make your space truly feel like a home for the both of you.
◇ Make a wall of your roommates' signs proudly displaying all of the characteristics and personalities that dwell together under your roof!
◇ Create a display that represents beloved family members and friends.

With so many ways to customize and personalize these prints, your art collection will never be dull or boring.

Simply detach the prints at the perforated line and frame them—just like that, you're ready to go. The prints measure 8" x 10" and will fit most standard frames. Or you can take it up a notch and add a mat, displaying them in an 11" x 17" (or larger) frame for a more dramatic presentation. If you are one of the signs who thrives on variety and change, be sure to use a less permanent hanging method—like removable picture hangers instead of the more traditional nails—so you can move your art wherever you desire.

And no matter how you choose to decorate, these gorgeous astrology-inspired prints are sure to bring color, style, and the influence and intrigue of the zodiac to your home!

THE PRINTS

ARIES

ARIES
March 21–April 19

Illustration by Priscilla Yuen

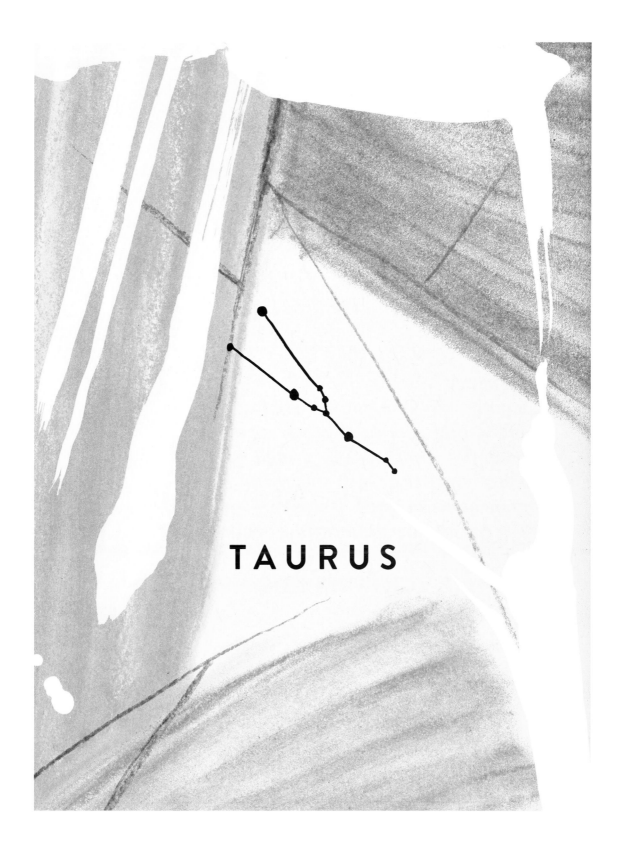

TAURUS

TAURUS
April 20-May 20

———

Illustration by Priscilla Yuen

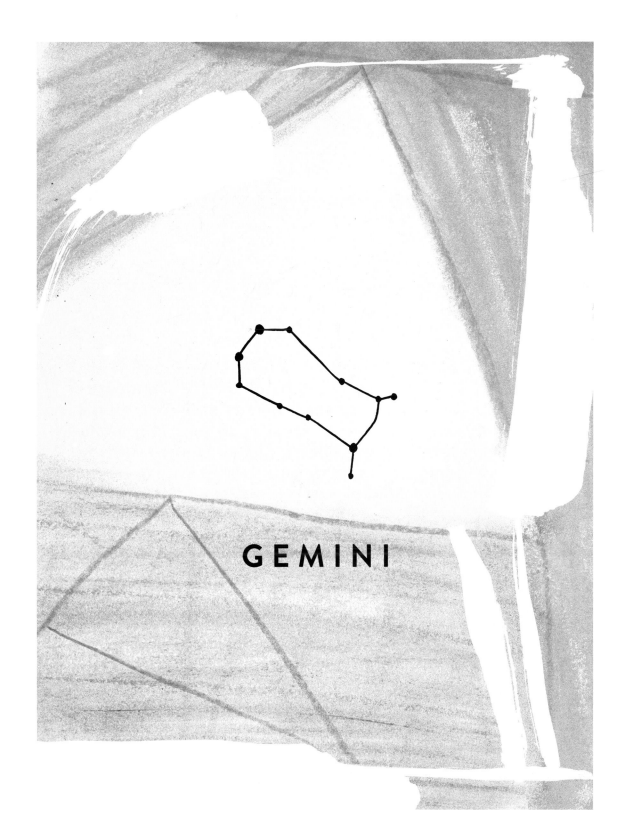

GEMINI

GEMINI

May 21–June 20

Illustration by Priscilla Yuen

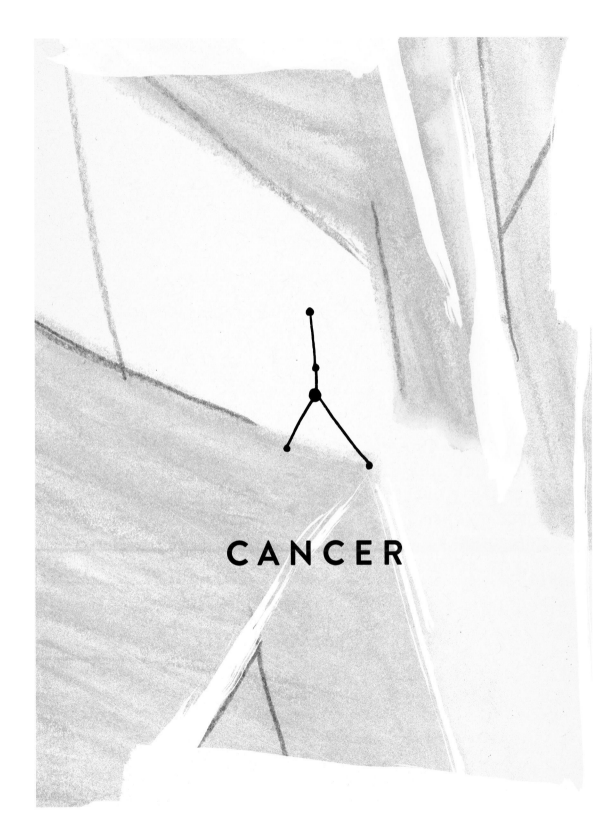

CANCER

LEO
July 23–August 22

Illustration by Priscilla Yuen

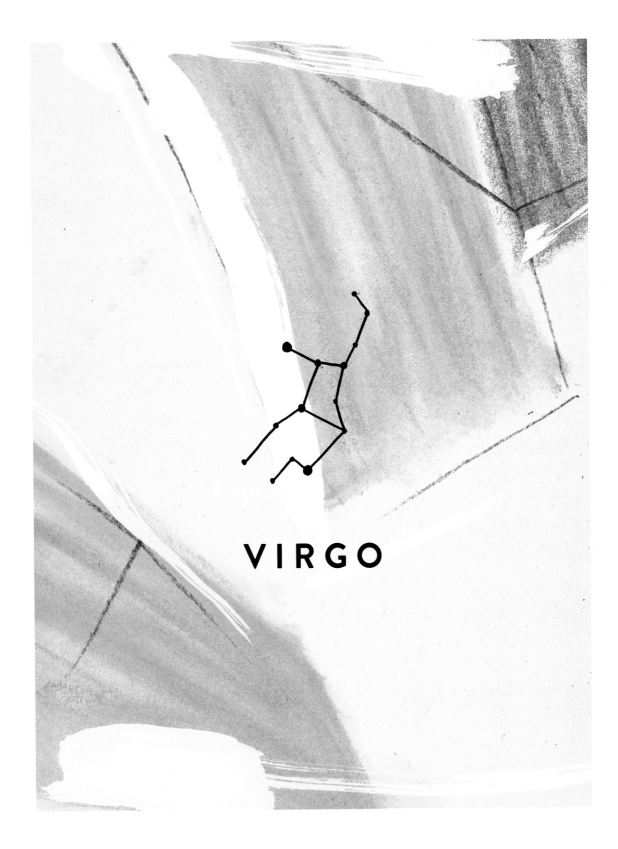

VIRGO

VIRGO
August 23–September 22

Illustration by Priscilla Yuen

LIBRA

LIBRA
September 23–October 22

Illustration by Priscilla Yuen

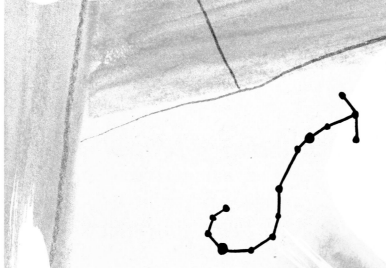

SCORPIO

SCORPIO
October 23–November 21

Illustration by Priscilla Yuen

SAGITTARIUS

SAGITTARIUS
November 22–December 21

———

Illustration by Priscilla Yuen

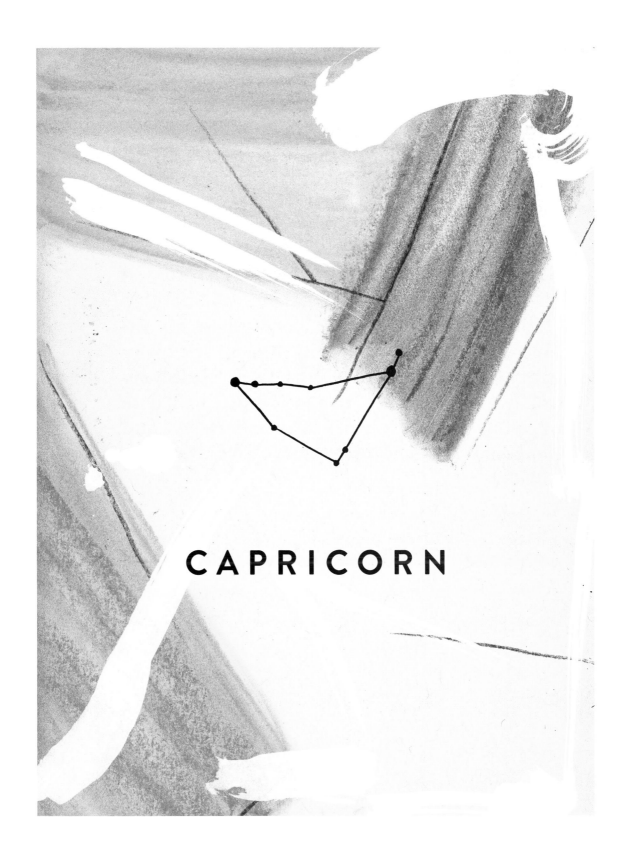

CAPRICORN

CAPRICORN
December 22–January 19

———

Illustration by Priscilla Yuen

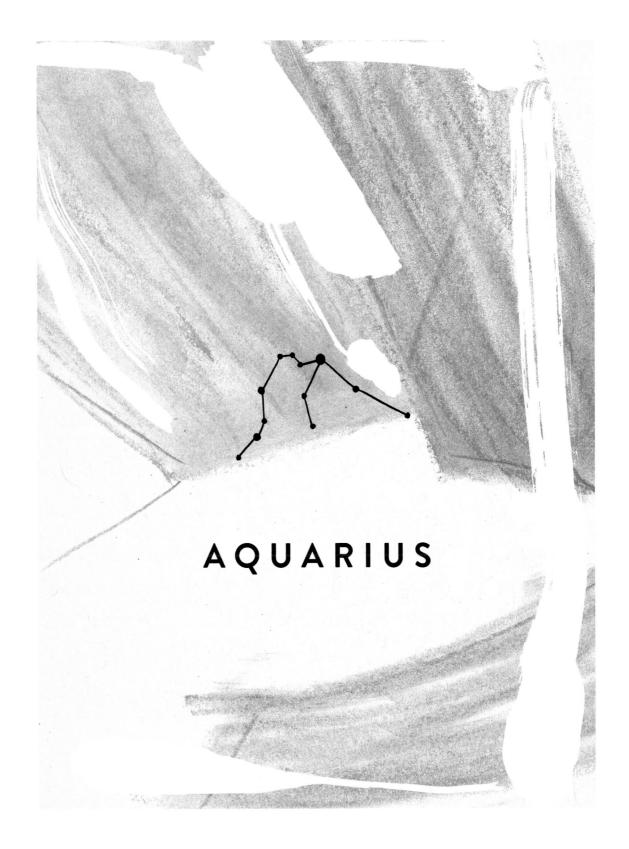

AQUARIUS

AQUARIUS
January 20–February 18

Illustration by Priscilla Yuen

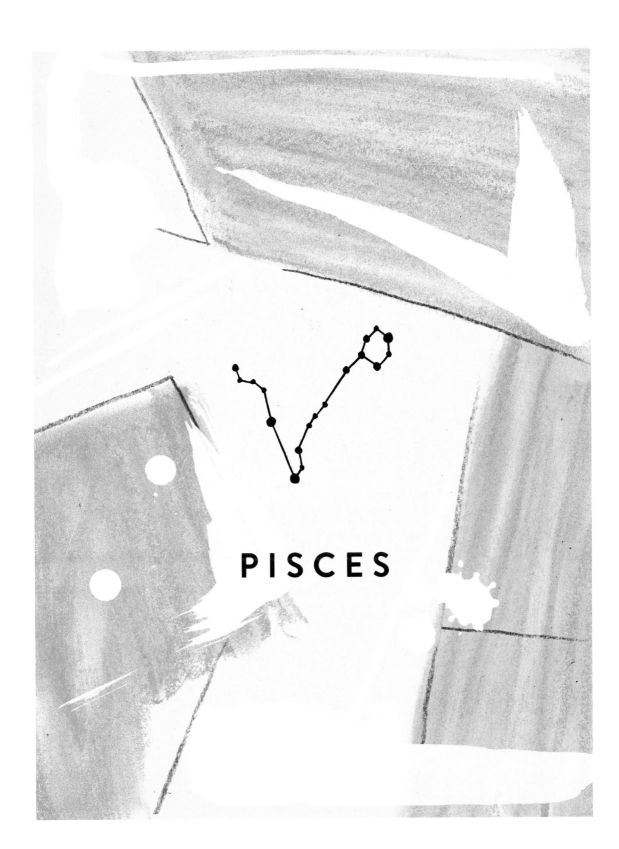

PISCES

PISCES
February 19–March 20

Illustration by Priscilla Yuen

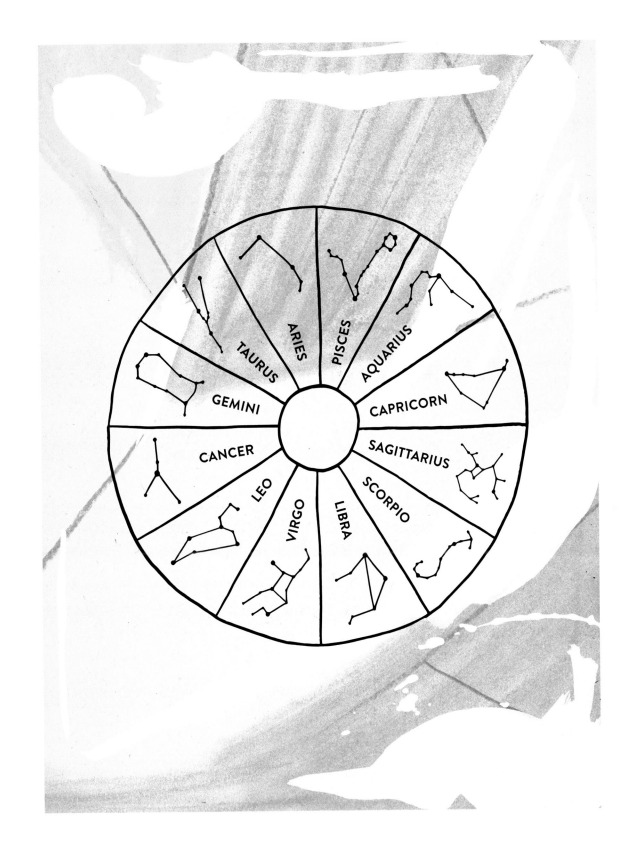

Illustration by Priscilla Yuen

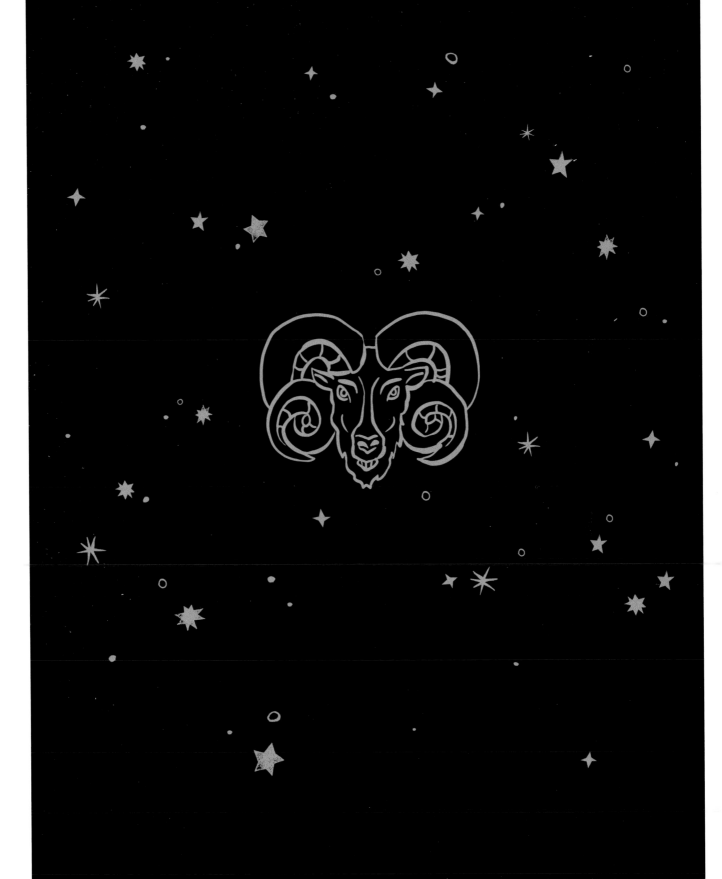

TAURUS
April 20-May 20

Illustration by Andrea Lauren

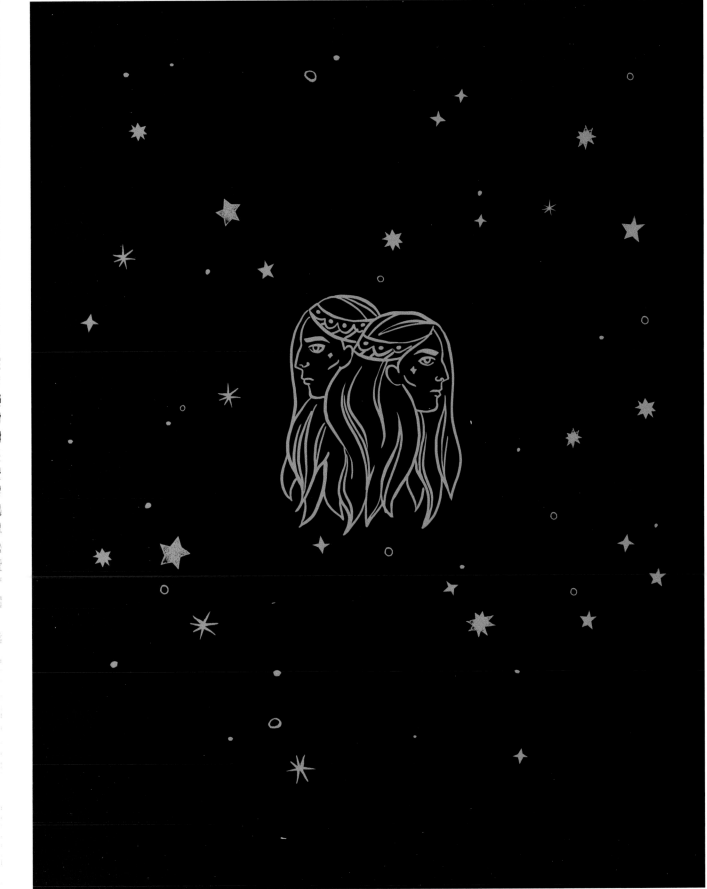

GEMINI
May 21–June 20

Illustration by Andrea Lauren

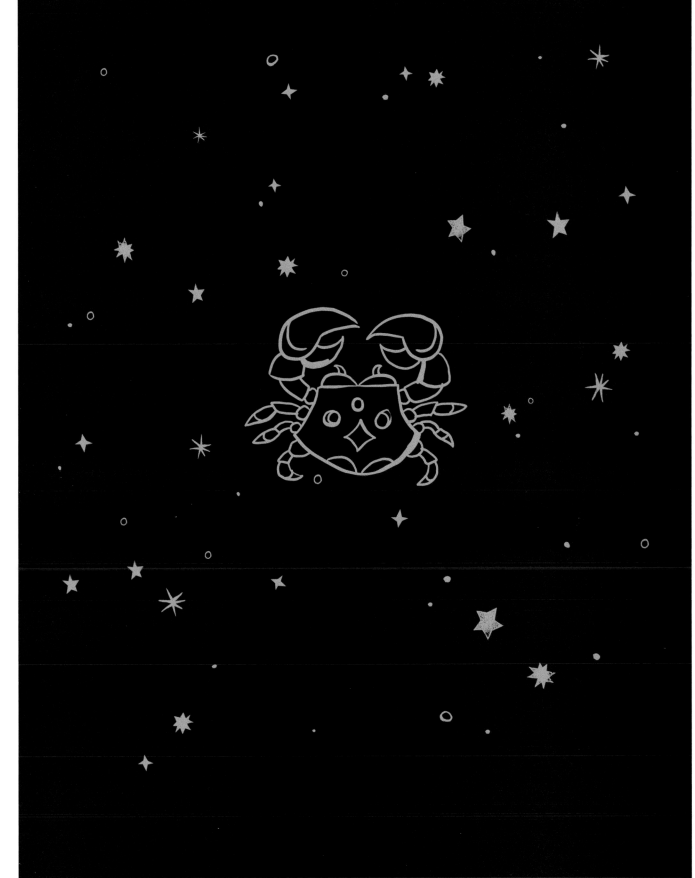

CANCER
June 21–July 22

Illustration by Andrea Lauren

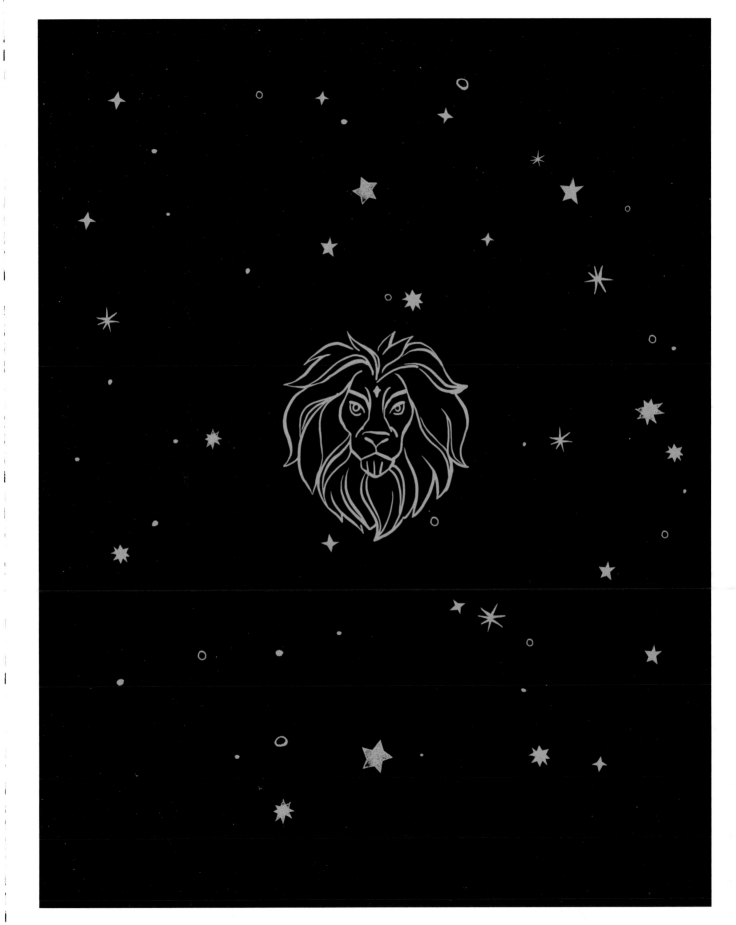

LEO

July 23–August 22

Illustration by Andrea Lauren

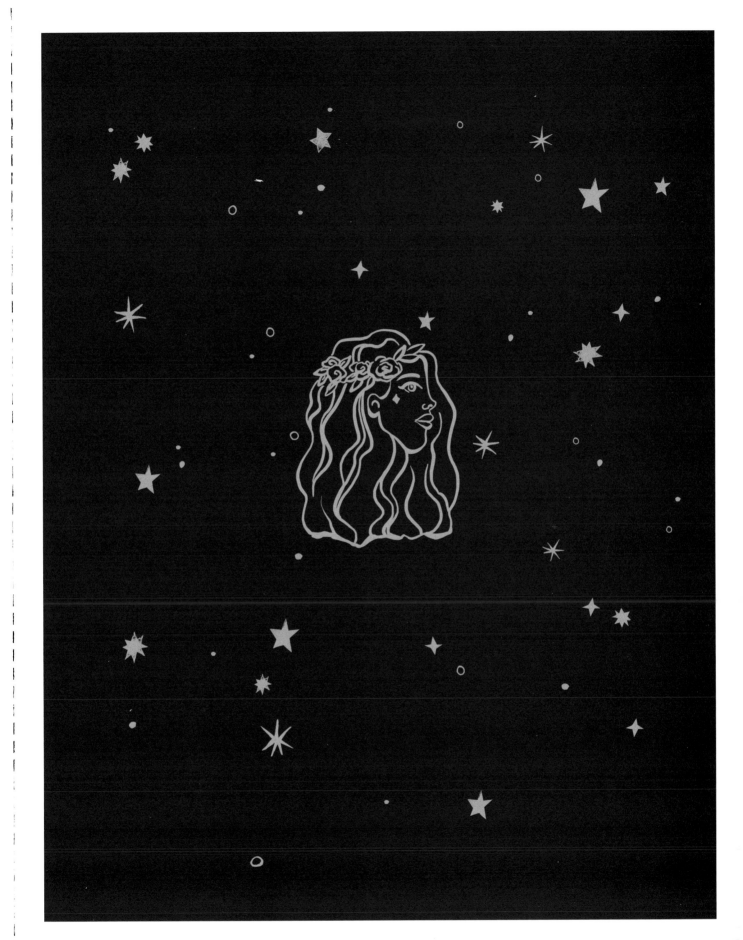

VIRGO
August 23–September 22

Illustration by Andrea Lauren

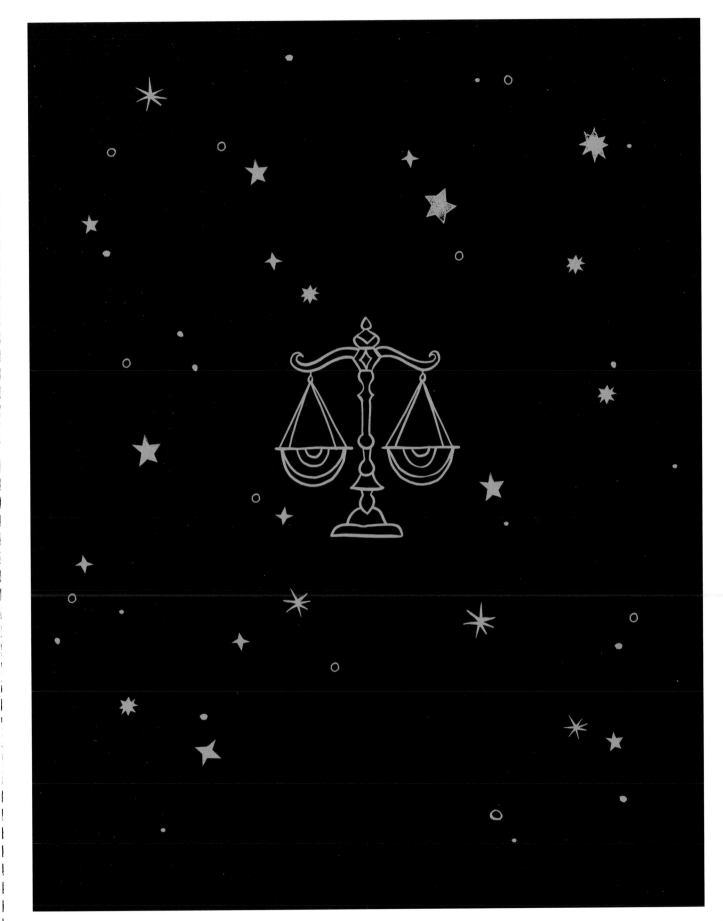

LIBRA
September 23–October 22

Illustration by Andrea Lauren

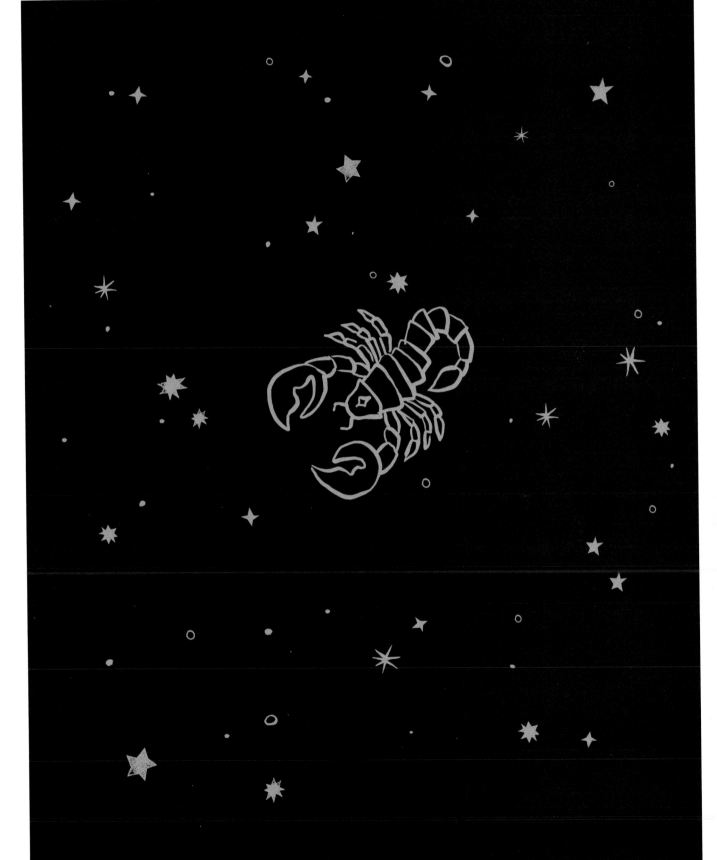

SCORPIO

October 23–November 21

Illustration by Andrea Lauren

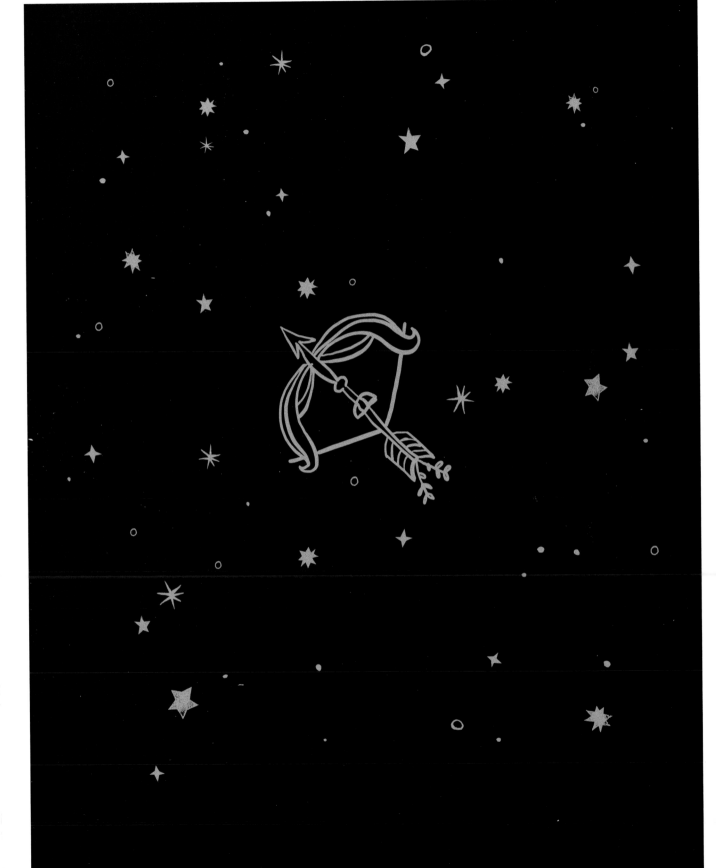

SAGITTARIUS
November 22–December 21

Illustration by Andrea Lauren

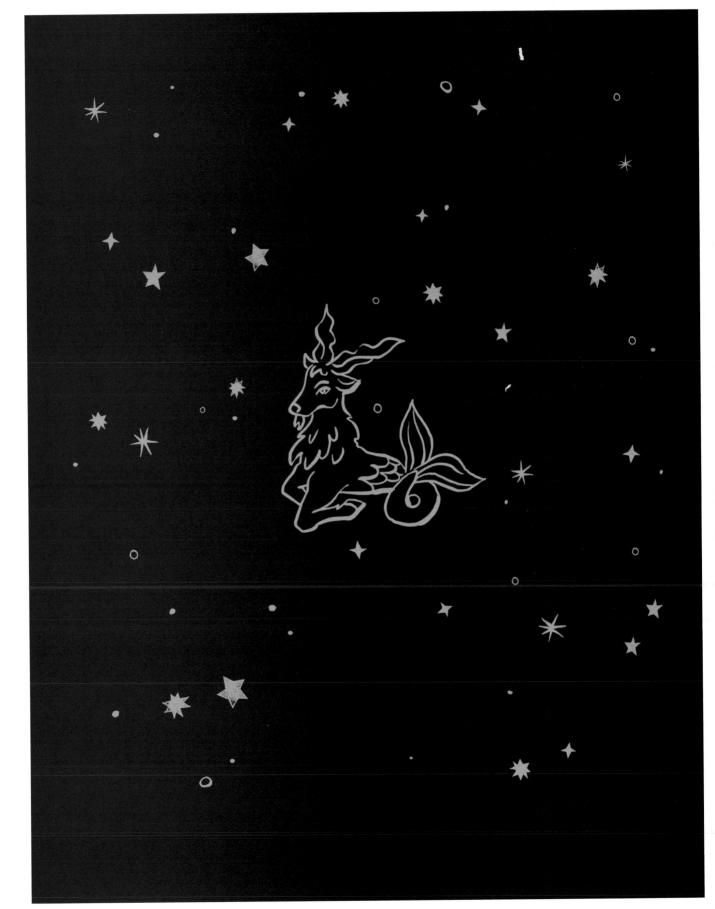

CAPRICORN
December 22–January 19

Illustration by Andrea Lauren

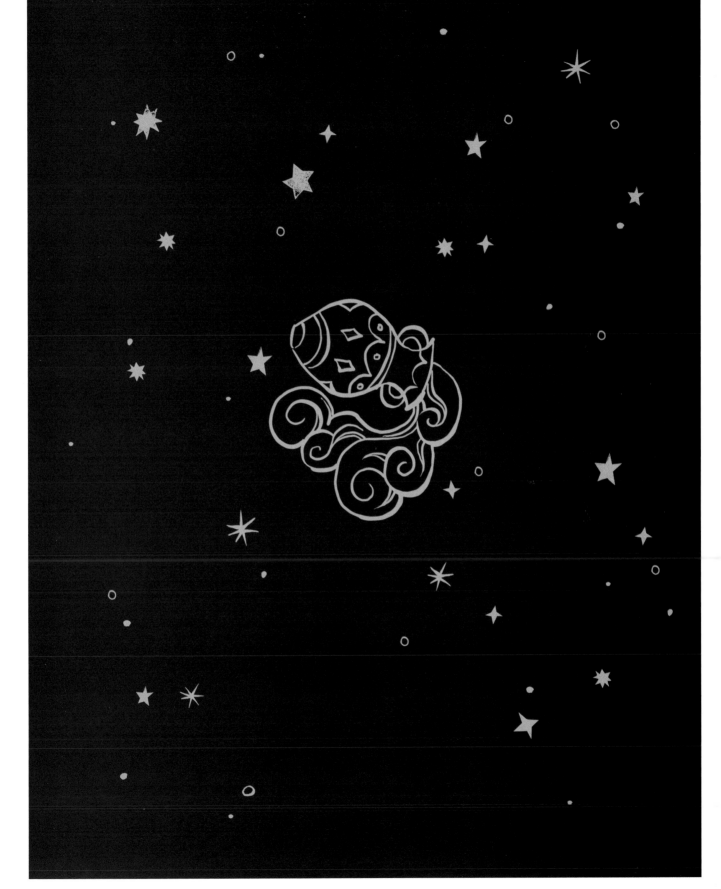

AQUARIUS
January 20–February 18

Illustration by Andrea Lauren

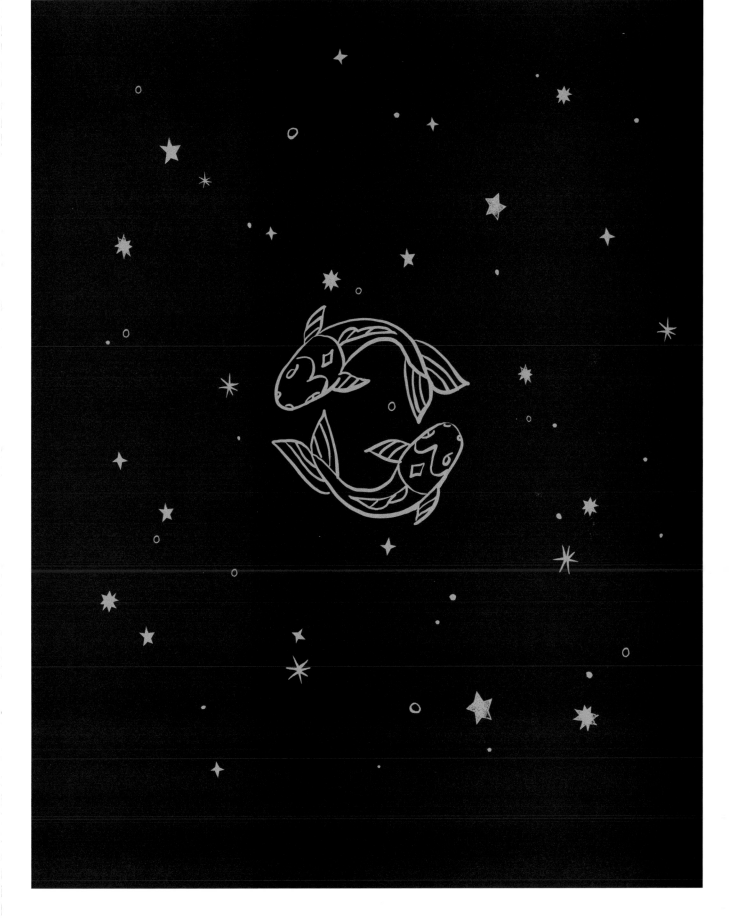

PISCES
February 19–March 20

Illustration by Andrea Lauren

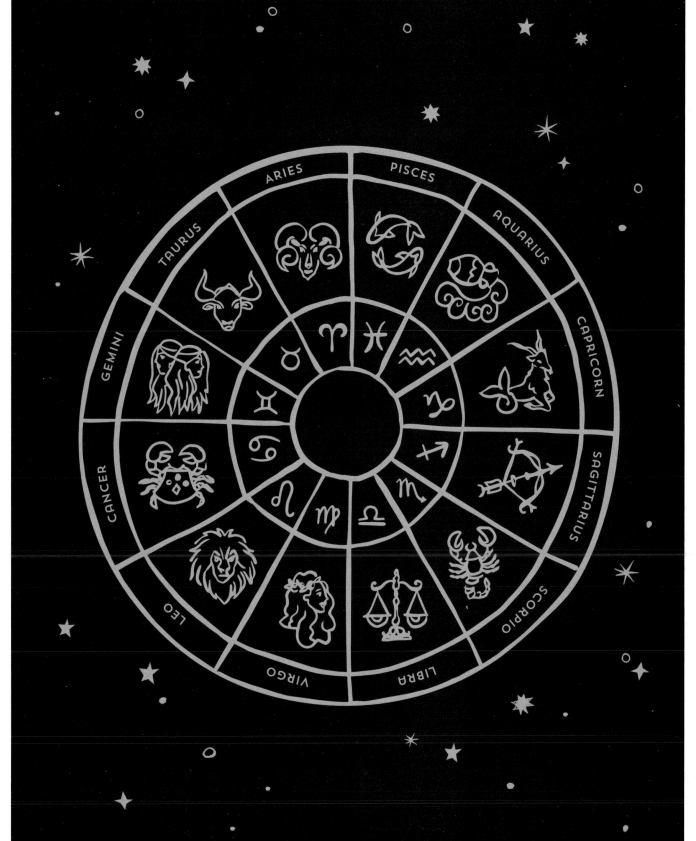

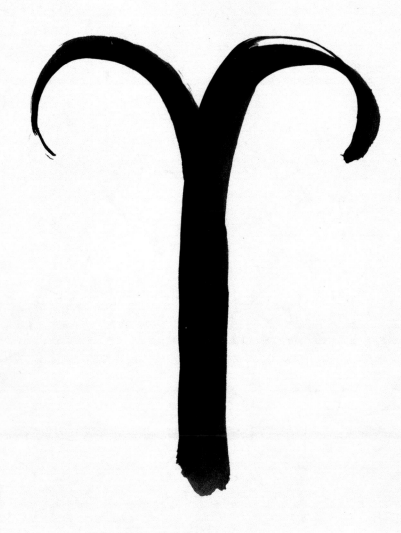

Aries

ARIES
March 21–April 19

Illustration by Priscilla Yuen

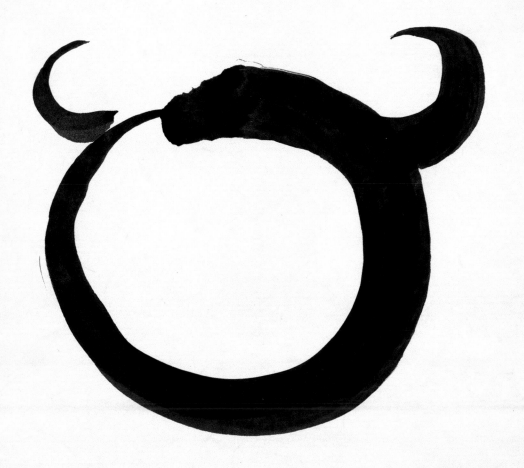

Taurus

TAURUS
April 20-May 20

Illustration by Priscilla Yuen

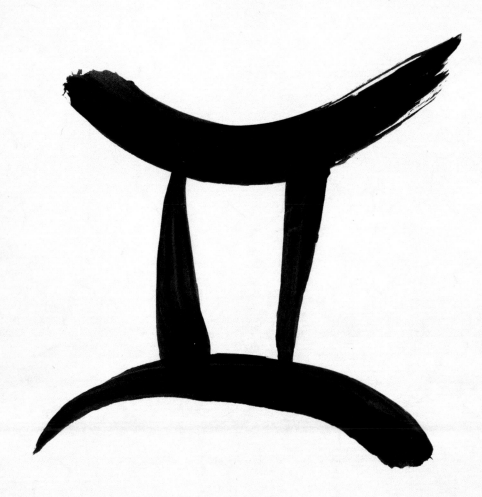

Gemini

GEMINI
May 21–June 20

Illustration by Priscilla Yuen

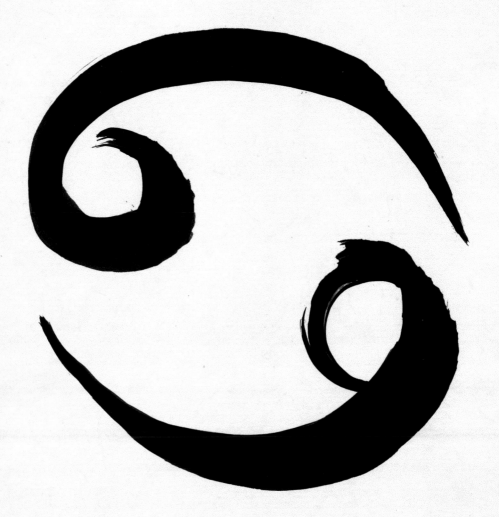

Cancer

CANCER
June 21–July 22

Illustration by Priscilla Yuen

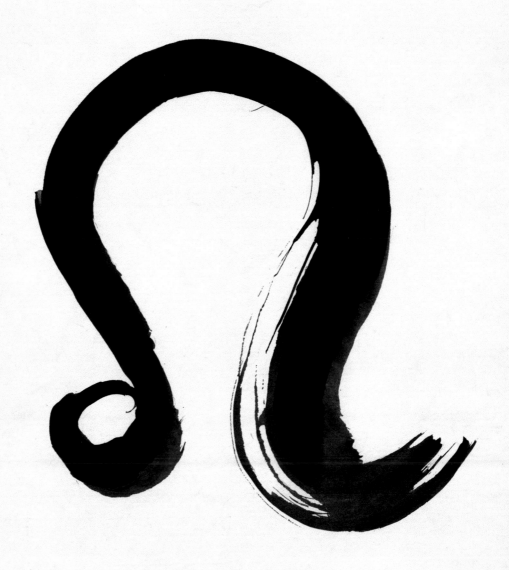

Leo

LEO
July 23–August 22

————

Illustration by Priscilla Yuen

Virgo

VIRGO
August 23–September 22

————

Illustration by Priscilla Yuen

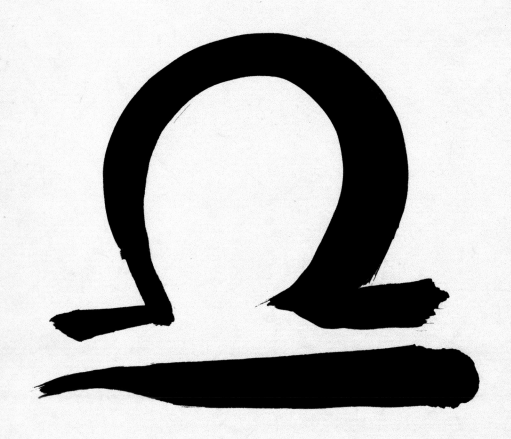

Libra

LIBRA
September 23–October 22

Illustration by Priscilla Yuen

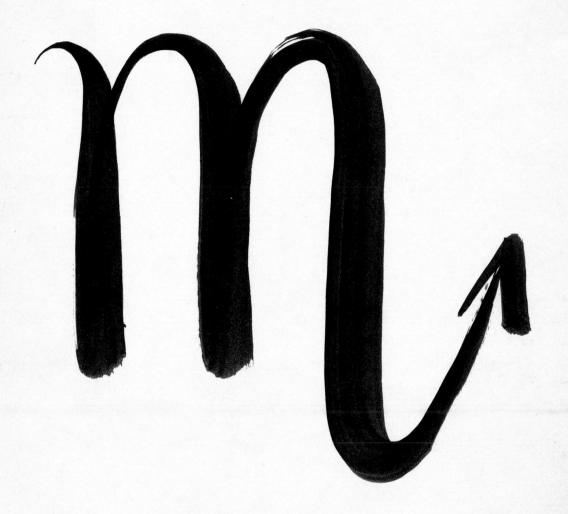

Scorpio

SCORPIO
October 23–November 21

Illustration by Priscilla Yuen

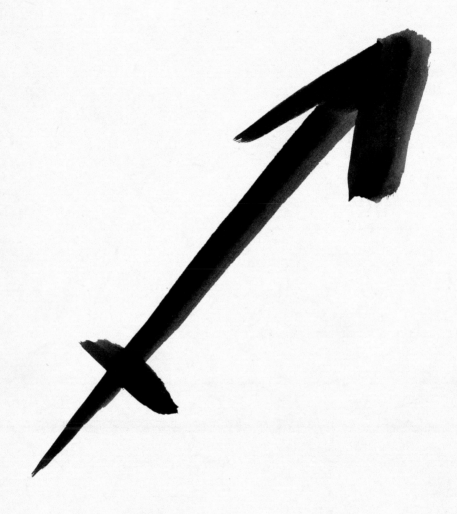

Sagittarius

SAGITTARIUS
November 22–December 21

Illustration by Priscilla Yuen

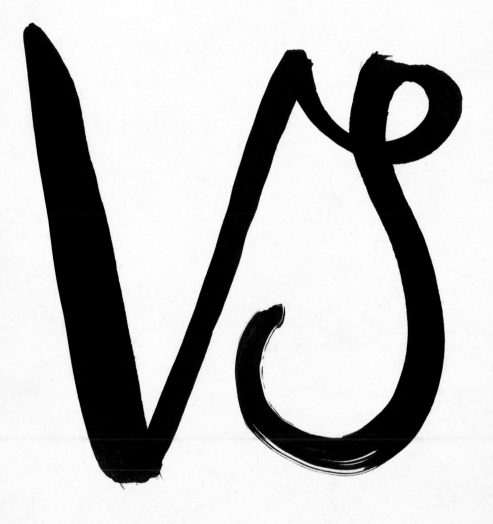

Capricorn

AQUARIUS
January 20–February 18

Illustration by Priscilla Yuen

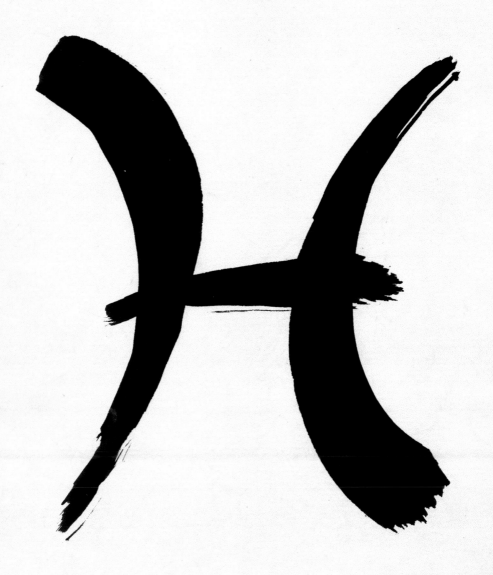

Pisces

PISCES
February 19–March 20

———

Illustration by Priscilla Yuen

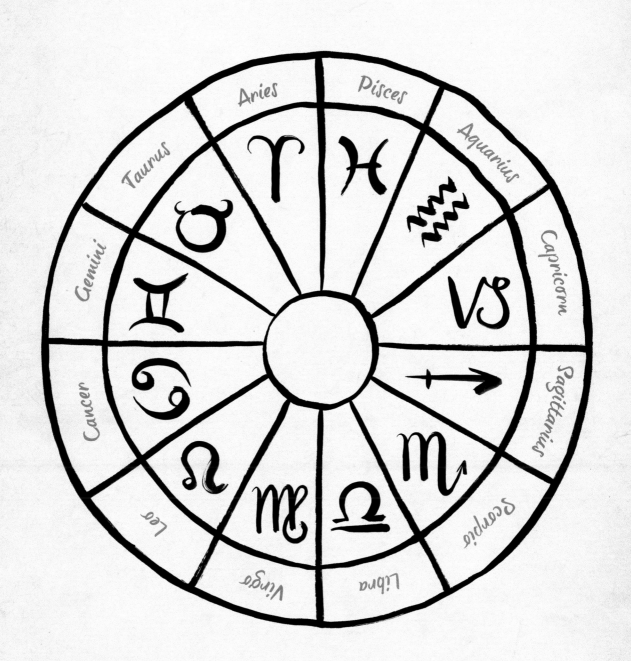

Illustration by Priscilla Yuen

ABOUT THE ASTROLOGER

PHOTO CREDIT: Claire Bush

CONSTANCE STELLAS is an astrologer of Greek heritage with more than twenty-five years of experience. She primarily practices in New York City and counsels a variety of clients, including business CEOs, artists, and scholars. She has been interviewed by *The New York Times*, *Marie Claire*, and *Working Woman*, and has appeared on several New York TV morning shows, featuring regularly on Sirius XM and other national radio programs as well. Constance is the astrologer for *HuffPost* and a regular contributor to Thrive Global. She is also the author of several titles, including *The Astrology Gift Guide*, *Advanced Astrology for Life*, *The Everything® Sex Signs Book*, The Little Book of Self-Care zodiac series, and the graphic novel series Tree of Keys, as well as coauthor of *The Hidden Power of Everyday Things*. Learn more about Constance at her website, ConstanceStellas.com, or on *Twitter* (@Stellastarguide).

ABOUT THE ARTIST

ANDREA LAUREN is an illustrator and printmaker who loves making linocuts. She grew up in England and her work is inspired by her favorite childhood memories of holidays spent in the New Forest, having picnics in the woods, and paddling in streams. Animals, florals, and nature prints make up the cornerstone of her work. Andrea is also inspired by folk art, mid-century illustrations, and her family. Andrea loves being a new mama and is living her best life with her husband, son, and two rowdy cats.

ABOUT THE ARTIST

PRISCILLA YUEN is an illustrator, hand letterer, and 3D artist from Malaysia who enjoys experimenting with various media and working with her hands. Brushes, ink, and paint are her preferred drawing tools, while embroidery, sewing, and sculpting are among the activities she enjoys best. Her dream is to have her passion for fabrication and children's books intertwined into a singular venture.